Futura-isms

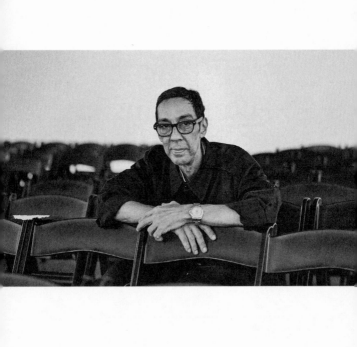

Futura-isms

Futura

Edited by Larry Warsh

PRINCETON UNIVERSITY PRESS
Princeton and Oxford

in association with
No More Rulers

Published by Princeton University Press, 41 William Street,
Princeton, New Jersey 08540
In the United Kingdom: Princeton University Press,
6 Oxford Street, Woodstock, Oxfordshire OX20 1TR
press.princeton.edu
in association with
No More Rulers
nomorerulers.com
ISMs is a trademark of No More Rulers, Inc.

All Rights Reserved
Library of Congress Cataloging-in-Publication Data
Names: Futura 2000, author. | Warsh, Larry, editor.
Title: Futura-isms / Futura; edited by Larry Warsh.
Other titles: Quotations. Selections
Description: Princeton: Princeton University Press
in association with No More Rulers, [2021]
| Series: Isms | Includes bibliographical references.
Identifiers: LCCN 2020037561 | ISBN 9780691217512 (hardcover)
Subjects: LCSH: Futura 2000—Quotations.
Classification: LCC NC139.F88 A35 2021 | DDC 751.7/3—dc23
LC record available at https://lccn.loc.gov/2020037561
British Library Cataloging-in-Publication Data is available

This book has been composed in Joanna MT
Printed on acid-free paper. ∞
Printed in the United States of America
1 3 5 7 9 10 8 6 4 2

CONTENTS

INTRODUCTION

FUTURA, born Leonard Hilton McGurr, entered into New York City's graffiti scene in the early 1970s as a young teenager searching for identity. At this time, graffiti was just beginning to appear in New York City in the form of text- and name-based tags on subway trains and other public spaces by a group of writers—mostly other teenagers—who adopted tags like TAKI 183, STAY HIGH 149, and PHASE 2. Futura, inspired by Stanley Kubrick's classic sci-fi movie *2001: A Space Odyssey*, joined this seminal first wave—creating the tag FUTURA 2000 (later revised to Futura).

When you think of the origins of streetwear and street culture, most point to Futura's foundational graffiti scene of the 1970s, as well as to early hip-hop and punk rock, Japanese street

fashion, 1990s skateboarding culture, or other countercultures of the late twentieth century. Few will recognize that simultaneously—within all of these strains—was Futura, the hidden influencer, with a foot in each of those worlds, revolutionizing from behind the scenes. His importance in the genesis of our contemporary culture, and his continued, expanded presence within that culture today, is a testament to his phenomenal resilience, subtlety, and perception as an artist. While time banishes some into irrelevance, time has only strengthened Futura.

Culled from close to forty interviews, conversations, lectures, and other primary sources from the past thirty years, this book reveals the mind—and consistency—of Futura throughout his many phases of development, from his experiences as an early writer in New York City subway trains, to his deployment in the US Navy,

his revolutionary impact on graffiti art, and his lasting influence on popular culture. Sorted into seven distinct chapters, the quotes address themes from identity and artistic process, to the art market, fatherhood, and advice to young creatives searching for their own identities.

Painting a picture of Futura's life—through language-driven anecdotes, asides, and additives—has been a beautiful quest, no less dynamic than the life events of the artist himself. After a four-year stint in the military in the late 1970s, Futura returned to New York and reentered into an expanded, vibrant, and more dynamic graffiti scene. Tagging had become more elaborate, turning simple one-dimensional tags into multicolored works of art with perspective, shading, and embellishments. Legibility had given way to artistic style and originality. Hip-hop, punk, and urban street culture were combining and

mixing, generating an exciting buzz of creative energy, and Futura started hanging out with other young artists such as Jean-Michel Basquiat, Keith Haring, Lee Quiñones, Lady Pink (Sandra Fabara), Kenny Scharf, Haze (Eric Haze), Zephyr (Andrew Witten), Dondi (Donald Joseph White), and Fab 5 Freddy (Fred Brathwaite), among others.

It was in this climate that Futura developed an entirely new abstract style that revolutionized the definition of what graffiti could be. First seen on "The Break Train," an entire car of a 2/3 train that Futura painted with vivid, nebulous fields of color and futuristic abstract shapes, he took what was still predominantly a text-based art form and cracked it open, creating huge, otherworldly abstractions where the signature was an accessory to the artwork itself, the spray can as legitimate as a paintbrush. He

took a contrary approach to his lettering too, developing an individualized alphabet that was elegant and simplified, countering the robust, three-dimensional bubble letters and wildstyle that were popular at the time.

Unlike his peers, such as Basquiat and Haring, who started off with graffiti but spent most of their careers in the downtown art world, Futura crossed over the line but never fully made the leap, instead collaborating and going on tour with the British punk band The Clash, proving his phenomenal ability to translate and transplant himself and his creative energy. Throughout the eighties, he was profoundly embedded in the cultural mix, generating ideas, merging styles and cultures, and contributing just as much as he was assimilating, turning even the world of bike messengers into a hip subculture after working a delivery job in the late eighties. After

graffiti's fifteen minutes of fame in the art world were over, Futura moved on to fashion, cofounding some of the first streetwear labels—GFS and Project Dragon—all inspired by graffiti aesthetics. He was there at the moment when people began to realize that urban styles could be mass-marketed around the world, and since then, he has collaborated with many of the key figures in the development of the commercial zeitgeist that engineers the platform of art-meets-product, including Supreme, Off-White, Louis Vuitton, Comme des Garçons, and many others.

The key to Futura's success, in my mind, is that he has never been stagnant. He has always been one step ahead, always stylish, always pushing boundaries while inventing them at the same time—inventing new ways of art making, inventing canvases, inventing his own identity. Futura follows his own instincts—like introduc-

ing camouflage into streetwear at a time when it was only seen on soldiers—and somehow it systematically, continuously hits the mark for what culture didn't know it wanted but was really thirsty for. He is always on the mark, all the time, his own personal zeitgeist consistently perfect for the moment. From a young teenager tagging subway trains to the silent sage on the mountaintop of contemporary pop culture, Futura and his continuous reinventions have influenced generations past, present, and future, across genres and nationalities, and will continue to do so.

<div align="right">

LARRY WARSH
NEW YORK CITY
NOVEMBER 2020

</div>

Futura-isms

Graffiti

The energy of that era was amazing. We were so young back then, but look at what we had control of. We took the transportation system of one of the biggest cities in the world. (1)

———

I'm a fan of my movement. I have respect for it, the history of it and my place in it. (3)

———

It was just about trying to find my own
space … And I thought graffiti was very
great at that in that everyone's tag
was completely unique. (19)

———

I think unfortunately the streets are
getting overrun. The streets in the bigger
cities are becoming ruined with all the
enormous stickering. If you look at
places now, it's becoming a little
crazy. That's not interesting.
Or maybe it is. (5)

———

The bottom line is, that regardless of what the "public opinion" is of the "art form" it has influenced thousands of young minds worldwide ... point-blank. (32)

———

At the core of graffiti writing, every young kid, male or female, who's doing that, the name they choose—and you can look at the junior high school level, you'll see it on book bags, books, this is my name, this is my nickname—everyone's sort of into that identity thing. (6)

———

Graffiti was a way for me to exist.
I wanted the world to know my name.
I wanted to be somebody. (27)

———

It all started to snowball in New York. So,
for the next five years, you have a full-blown
art movement with gallery support. Kids
[were] still doing trains in the morning, then
having an exhibition. It was just a mélange
of everything. (7)

———

In 1981, that was this massive group show where it was all this subway folk—Rammellzee was there, Ali was there, Dondi [White], all of us … and this influx now of what was considered to be this new art movement in New York City, which was all coming out of downtown. And I hooked up with Keith [Haring]. And I met a homeless kid named Jean[-Michel Basquiat]. And they were coming to us knowing about art. Because they had read, they had read about art. (19)

———

In 1980 when I painted the "BREAK" [train], subway cars, I looked to define myself as someone who was searching for a new direction in aerosol art. What I was also doing was trying to paint what someone named Futura 2000 might paint. Sci-Fi shit. The fact that everyone would define me as the abstract expressionist was a bonus and proved to be almost prophetic. (10)

———

Things really accelerated with the "BREAK" train. Basically, the beginning of my career as Futura the abstract artist and the elements we see today were on that train in 1980. (18)

———

Today it's easier to communicate than we once did with a marker and spray paint; it's not limited to writing on the wall. Everyone's doing it in a different way. Some people communicate through their sense of fashion, some people are writing, some people take photos. (12)

―――――

The essence of what graffiti is ... is creating this identity and taking it to the public. (14)

―――――

Best part. Seeing the logo in the public eye. It's what graffiti draws inspiration from. (9)

―――――

Some of us, like me and Stash [Josh Franklin],
we're all still survivors, still pushing through
time with our work. (1)

———

1980 was the breakout year for us because
we were all beginning to surface. (17)

———

I'd come out of four years' service in the
military, and I was thinking, *I've been around the
world, I've been in Mombasa, Kenya, Karachi and now
I'm in a New York Subway tunnel?* (18)

That was the whole purpose of what we were doing and who we were. Is that we all grabbed noms de plume, pseudonyms, aliases, tag names … Some people with multiple tag names because one wasn't good enough. (19)

———

That's another story about letters and how we were all about letters. It's sort of the foundation of our culture. And, you know the old adage, like, "What's in a name?" Like, what's the name mean? Does the name mean anything? Does it sound cool? Did you like those particular letters? (19)

———

We were … slightly criminal. You know, it was a little bit of misdemeanor crimes. I mean, we're jumping over turnstiles; we're breaking into subway tunnels. But I mean, I wasn't a stick-up kid. I wasn't a real thug. But we were considered thugs. (19)

———

Spray painting and art are a combination of stenciling, skill, ability, and can control, for example, and there is a certain level of technique that you have to bow to. But what's happening now is that younger artists are coming up and they have nothing to do with that school of art. Whether they're trained artists or just those prodigy-type kids that have a natural ability, they have no problem with scale, and I believe that will mark the new arrival of technical ability in my field. (2)

Andy Witten a.k.a. Zephyr, who was a very good friend of mine, came to say, "Hey man, this guy wants to organize us to go into his studio. It's paid for two months. We've got materials, we've got spray cans, we've got canvas. We've got everything we need. And let's make as many canvases as we can in the 60-day time we had. ... Let's invite all the writers that would like to participate." (19)

———

I saw everybody paint, I saw people painting left-handed, I saw people painting upside down. I saw everything. And really it was such an education for me as just a creative guy watching people work. Which to me is still the beauty of any of this crap. Seeing someone do what they do, that's the essence. Just watching someone do something is awesome. (19)

———

Subway art and spray can art wind up being the new testament and the old testament for our culture in terms of books. "Wild Style" and "Style Wars" are equally as important, if not more. (19)

———

In '68, I'm 13 ... You're coming from a period of anti-war, protesting. I think before I saw tags on subways and stations and random tags on walls in New York, I would see more political messages. So, my approach comes from more of a political, I think, era than anything really ... I still attributed graffiti to that. It was ... kind of a radical, "Well, hey, let me express myself this way." That was it! (20)

We like to think we're the mecca [in New York] for this whole story: someone like Lee [Quiñones], who was painting trains in the mid-'70s; Crash, Daze, and work that can be seen through photography of Henry Chalfant and Martha Cooper with artists; Rammellzee's work is here, rest in peace. Dondi White, rest in peace, Stay High. So many of our lost graffiti alumni, not to mention the Jean-Michels and the Keith Harings. And the Andys. There's a lot of people who are gone who were also very much part of this whole story. (4)

———

I guess at some point I started to see the writing on the wall and figured out maybe this could be something interesting to do. Just from a "Hey, let me participate," you know, "Hey, I exist." (20)

———

You would meet people who had different affiliations and had territory and sort of took ownership of those yards ... Which I think was a cool thing. You could be some 15-year-old kid but that was your yard. Or, like you and a few other people could claim that. It was pretty outrageous. (20)

As a teenager growing up in the late '60s and early '70s of New York City, I saw graffiti, as "the writing on the wall," which very much spoke to me in so much, as it was the spark I needed, to ignite the flames of self-expression.

(23)

———

Back in the day, we were more collective because we were all still an ensemble of characters that arrive in the scene; we were part of the same performance. (1)

———

I connect[ed] with Stash [Josh Franklin]
at his studio and [saw] what he [was]
doing … messing around with, like, Krylon
logos and Rust-Oleum logos. He [was] already
setting the groundwork for someone who
comes from the graffiti culture. It's not even
graphics or anything … just reppin' brands
from the culture. These [were] spray can
companies we're very respectful of. (20)

I try to stay positive and appreciate life as
it is, and not be super self-absorbed. I think
that's the nature of graffiti. It's all about your
identity, but at the same time, I never feel like
I can't get with a social group and just be one
of the guys, and help out in some capacity. (29)

It makes perfect sense that the subway system would literally become the "vehicle." It just happened, it invited it. Suddenly graffiti wasn't limited to tenement halls, school yard walls, and bathroom stalls. Graffiti had found the speed at which it needed to be seen. To keep in step with the fast pace of communication and information sharing. What had started out as playing in subway tunnels had progressed into midnight forays deep in the interiors of the system. (30)

———

Equipped with a duffel-bag containing over 50 cans of spray paint, we had planned to do pieces on all 6 trains that were in the tunnel … Suddenly there was this enormous flash and the next thing I saw was a ball of fire that had engulfed my friend instantly. Defective paint, mysterious spark, or fate dealing the cards … what is certain, is that my life would never be the same again. (30)

———

I understand that the Futura signature [that] was once a graffiti tag on the walls of New York subways is now a brand.
And I'm cool with that actually. (31)

———

Perception and reality are dueling banjos when it comes to describing how people feel about my work and this movement. (32)

———

THE GREAT DEBATE / the "is it art?" discussion / or / but "if you sell your work, that's not graffiti" (32)

———

The "writing on the wall" inspired me. All those names ... all that style. I knew this was something I wanted to do. I just needed an alter ego, an alias, an identity. (32)

———

These other lesser known individuals, who
have made thankless contributions to a
movement spanning some thirty years.
Nameless, styleless, faceless: famous, infamous,
pioneering: these "kids/now: men/women"
have inspired generations. Locally, it all grows
from reputation, talent and fame. respect
comes from those who deserve it. The
childlike game of >show and tell< (32)

Some writers from this school [graffiti] have
become recluse and satisfied with just living
off the fame they created so many years ago,
while others still struggle for acceptance and
find the transition quite shocking. (32)

Regardless of what writers feel about this …
and it's a great debate … work in the public
space, is still work in the public space. Legal or
not, artists should concentrate on making
GOOD WORK, because that's all you'll be
judged by. That and the negative shadow the
"G" word casts over us all … PROVE
THEM WRONG!!!!! (32)

———

Without question, my involvement in the
[graffiti] movement has elevated me to a
status I never imagined, and for that I am truly
fortunate. Despite the ball and chain of
"graffiti" around my neck, the paradox is, that
without having been a graffiti artist back then,
I wouldn't have the life I'm living today. (32)

———

I encourage artists to take available space, whatever or wherever that might be. With the exception of defacing monuments and other obviously off limit locales. The problem with "designated graffiti" is that other writers who aren't down, will see this as a reason to cross each other out. It's the fox and the grapes every time. (32)

———

In my element, within the system, I am poised to commute with humanity on a daily basis. (32)

———

It's not the word "graffiti" that bothers me,
it just doesn't accurately explain the
entire picture. (33)

———

I was always at home in the subway system.
(30)

———

Family and Social Life

I have two children: Timothy and Tabatha; ...
they are the foundation to the architecture.
Without them this would be a shallow facade.
(9)

I am more proud of my kids than I am of
any other creative accomplishment. (5)

TIMOTHY&TABATHA will forever be
works in progression. (15)

That's wonderful ... when you can tell that
people are sincere and the motives are
genuine. (1)

It's great to not be so serious despite the world being quite harsh at times. There should be time for laughter, play, comedy, and a bit of self-deprecation too. (2)

———

In the past I used to be a little more, "Yeah, it's cool. Let it all happen when it happens." Now I am trying to help it happen. And it feels great. It's wonderful just to have the support from my community and the culture at large. (4)

———

Now that my children are young adults and they are doing really well and we all are there for each other it's like a dream come true. I couldn't have imagined anything better. I'm not without some mistakes along the way, but it's quite a commitment I think, to be a parent.

(5)

Let me please say I have an eternal flame for Agnès [B.]. She was perhaps the most instrumental figure in getting me back into my artwork in the late eighties, providing me with a studio in which to work. More than a quarter century later, she's still supportive and without her presence my French connection wouldn't be what it is. (10)

But even Keith [Haring] and [Jean-Michel] Basquiat, when they weren't someone of an older age, in fact they were younger but they were contemporaries and we were learning from each other. I mean, Keith was enormously supportive of his friends and things that were in the sphere of his grasp and the way he could help people. I'm also a byproduct of people being kind to me, generous as well. Opening doors for me. (11)

———

My returning to New York, post-military,
coincided with the meeting of Keith [Haring]
and Jean-Michel [Basquiat]. (13)

———

Mark Parker [former Nike president] invited
me to the 2003 Tour de France [but] I had
other obligations, but last year, Mark said "the
offer still stands" and I came here and had the
chance to follow the Tour for a week. It was
the biggest rush of my life. If you love cycling,
to get the VIP treatment was great. (16)

———

The day I met Robin [Williams] at the Tour,
he was wearing one of my T-shirts! He was a
fantastic guy who shopped at our store
in San Francisco, so he's a fan and a
supporter of our culture. (16)

———

For me now, yeah, I'm grateful that my
demographics are somewhere between 22
and 47. I'm fortunate that that community
is there for me. (19)

———

It's Jahan [Loh] who's my conduit and
connection to Singapore. (1)

———

Lee Quiñones [is] a king who has no
contemporaries. [H]is body of work is
perpetual. (9)

———

Rammellzee, your basic genius maniac,
his manifesto kills it. (9)

I was asked to do a backdrop for [The Clash]
with Zephyr and Kiely Jenkins. The shit was so
big; it was like 20 meters by 20 meters. (19)

———

I loved Steve McQueen, I loved Sean Connery.
I mean, you know, movie stars were cool.
Music was cool. But these kids who lived in
my city and were doing this work day and
night were the most amazing people ever, and
to be part of them—but more importantly to
be accepted and respected by them—that's
really all I was looking for. (19)

———

I didn't want my son being an artist. A child of someone famous is always going to be subject to a kind of legacy and like, "Oh, your parents have done something for you." (4)

———

I won't say I knew Andy [Warhol] well, but socially, yeah. I used to see him at stuff, and I was really good friends with Keith Haring and Jean-Michel Basquiat. (29)

———

Rest in Peace Joe Strummer, one of the sweetest guys and kind of like almost a father figure to me in his wisdom and the way he talked to me. (19)

—

Meeting Nigo and working with A.B.A. [A Bathing Ape] was a turning point for me in terms of a catalytic event. I was highly inspired and immediately motived. (9)

I was very intimidated by someone like
Andy [Warhol]. Just looking at him as some
sort of an art God, and here I was an aspiring
artist at the time. Andy was really sweet to me,
he always had something really nice to
say to me. (29)

———

I've often said a lot of my role models are no
longer here, unfortunately. I always thought,
"Well maybe one day I'll be able to influence
someone, a younger person, to be creative,
to explore their self-expression." (29)

Identity

My whole life, I think, I've been a nomad. (4)

———

My school comes from a little bit of angst and rebellion. We were a part of a society that was not really happy with everything, and we wanted some change in life. That's how the graffiti thing happened. I think we really wanted to express ourselves. We were willing to break the law to do that. (4)

———

**[Do any persons, things, or events
influence your work?]**
Family, competition, fire, Newton, sex, colors,
space, computers, earth, sounds, erector sets,
Bruce Lee, food, odors, water, cycling,
[Stanley] Kubrick, motion, experiences,
travel, Darth Vader, spray paint, the
way someone smiles. (32)

———

At some point, I started making my own
choices—instead of being asked, I'm asking if
I can do it. But that took a bit of maturity
from me, to grow up enough and to be
confident enough to make decisions about my
work rather than depending on a friend or
asking someone famous for favors. (1)

———

I try to accept my identity and I'm very grateful. But at the same time, I like to get out of it and not worry about Futura and just be me. (1)

———

There's a part of me that completely wants to go off-campus and discover something, make mistakes, screw up and realize I screw up. (1)

———

I've lived almost like a couple of lives—a couple of worlds, even. (4)

———

From age 13. Gristedes. grocery bagboy …
McDonalds. grillman. Owens Corning.
delivery driver. NYC T&LC. driver. United
Airlines. airframe and powerplant. ELITE.
messenger. U.S. POSTAL. mail sorter.
. and yeah KINKO's. color copyop. (9)

———

I think everyone has to grapple with their
own morality thing. It is hard. That was such a
valid argument in the '80s when it was first
happening. Like how do you guys feel about
putting your work in a gallery when it's
supposed to be free for the public? (7)

———

All these clichés about, "act now," blah blah blah—I listen to my own conscience. (7)

You look at the global. You start thinking, "I'm a citizen of the world." I don't just live in America. (7)

I'm a closet sports guy, always have been. Crazy into stats. And anyone who puts up BIG numbers. (9)

It's very important for me to not live there,
in the identity of the artist. (10)

———

I am a walking paradox. I chose this activity
more than forty years ago, to get recognition
and respect. Now I would wish to escape from
that position from time to time. (10)

———

Prior to 1980 and all that, I spent four years in
the US Military. And I was on aircraft carriers.
So that four years was my higher education ...
not in art, not in academia, but in life. (19)

———

I left New York, day one, got my sneakers, got my laces, got my Kango, fucking shit looking cool ... I came back looking like some wanna be hipster from the UK with like a greaser jacket, a leather jacket, I had some Vivienne Westwood pants, I had some Teddy boy shit on. I mean, I looked like a doofus, okay? But I had already been influenced by these guys. And I came back and heads were like, "Yo, what happened to you?" And I was like, "Dude, I went to Europe, okay? You fuckin' got to get out there." (19)

I was one of the coolest bike messengers …
Oh, yeah, by the way I'm at the beginning
of that fuckin' movement! (19)

———

I am calculated and I am tactical. But at the
same time I don't have a master plan. I'm
kind of an organic flow guy. (19)

———

I feel like I've been just a real guy who isn't
looking for anything other than the moment.
And making it cool for us all. And giving
my all at all times. (19)

———

You know, basically just don't be screaming
about all the shit you can do. Just do what the
fuck you do. It's like sports, it's like anything.
Let what you do speak for itself. Because in
the end people will see through the bullshit.
And in the end today, people see the
bullshit way quicker. (19)

I can suss out a room and know
where I should be, know where I should sit,
where I should break out. (19)

Coming from sneaking around subway yards a few years previously to sitting in the cockpit of an F-14 Tomcat—like on the flight deck of an aircraft carrier, off the coast of Thailand or wherever the hell we were in the Pacific—was pretty radical. (20)

———

I just happen to have an edge more towards military-type designs. It's just a product of my environment. (2)

———

When I came back to New York in 1979 after being in the navy for four years, I'd been around the world, to Mombasa Kenya, Pakistan, Australia, all over Asia, the Philippines and Japan, and most of my friends hadn't left the block. (13)

———

I chose the name FUTURA2000, because
I felt it reflected who I was and what I
represented. I had always loved SCI-FI, and
was always guilty of gazing into the future.
I began innocently, writing my name here and
there, very harmless. But soon I began to feel
the excitement. Without realizing, I found
myself addicted to tagging, bombing and
getting up. Not to mention the sweet smell
of FLOMASTER ink. Through the 70's the
movement picked up speed, as select
individuals pioneered the applications of
spray paint. What once looked primitive
and childlike had become accomplished
and developed. (32)

———

It was supposed to be Futura 2001 but I didn't want people to come up to me and say, "Oh, like the movie." So, I knocked down a number.

(27)

———

I would say that no artist has inspired me. I always try to find a negative space. (28)

———

But when I started painting, I wasn't looking at who was doing what. I was looking for what didn't exist. I'm influenced by life itself, whatever I'm exposed to. Because painting is an emotional experience it's not like "Oh let me do a logo for Supreme," where it's going to be crafted and clinical. We know what they want, whereas with painting it's more like "Let me show how I feel," and based on my feelings that's how I'm going to work. (28)

I've always been a black high-top guy. I like the low-tops in the summer. There were really no other choices. There was no other footwear. (29)

I just want to wake up tomorrow and try to be happy, and that is a good day for me. (29)

———

My name just came to me one day, a combination of my favorite film (2001: *A Space Odyssey*) by Stanley Kubrick, and the Futura typeface. "Futura" represented, obviously, the future, and the "2000" was a projection of that thought. (30)

———

Music has always been a part of my life, from Frank Sinatra to Kendrick Lamar. The whole range. (11)

———

The Clash put me on the map, with visibility and recognition other than what I already had in New York as a kind of underground graffiti writer. (16)

———

I'm not how I used to be, where music was a necessary soundtrack to my life. I appreciate silence. (13)

———

I feel timing and this whole move coming back around. You know, everything comes in circles. And I'm just grateful to still be relevant and healthy. (4)

———

Today … Everybody's settled in and just doing what they're doing, and they don't want to mess anything up. And that's it. It's a different world. So, it's not possible to be as wild and like, "Ah, yeah, fuck it," as we were. (4)

———

You just need to keep moving. Don't stop. Just keep moving. (27)

———

Because this is my story. And I own it. (32)

———

Method

Organic is always the best kind of recipe. (1)

I feel like artists and individuals get to
a certain point where they're comfortable,
and the stagnation starts. They don't want
change because change can be dangerous
or unpredictable so they'd rather
keep it safe. (1)

With every idea and decision, it's not always the right one. (1)

I'm wondering if this is the time to throw more coal in the engine and get it really bubbling or do we let it stop and build another one. (1)

My style is abstract, next level, unconscious, different. (32)

It's about maintaining originality, and Jesus, man, it doesn't take much. I'm just going to lay back and let my work speak for itself, as it always has. You know, all these sneaker heads and all these Supreme kids, everyone is just a part of this feeding frenzy. I gotta get them off that. You won't be seeing any of my stuff like that anymore. You know, commercially available. I think it diminishes things.

It takes away your super powers. (7)

———

What I do has always come very easy to me. I can usually calculate my own actions, and prepare for anything that arrives based on practical experience and some wisdom. What I can't calculate or depend upon is the actions of others. (10)

―――

My name is a direct bite/snatch, not from the typeface though, when I was a kid, I didn't know about the typeface but I knew about the car. The Futura car, which is a Kennedy-era 60's Ford. And actually, if you see the script on the Falcon, the Futura signature is a little derivative of that logo. (11)

―――

Searching for a particular style and trying to
separate myself from the rest of the field has
always been a personal motivation, and in so
doing, I continue to make work. After a few
shows and 4 or 5 paintings to my credit,
I stumble through the process of learning how
to paint. I remain very critical of my own
work and looking back some many years,
I don't have any favorites of that early era.
Lacking direction and filling spaces, I was
attempting to discover a new medium in
painting and myself. Always working alone
and careful to guard the secrets of my
techniques, I still found it difficult to
create new work for the growing number
of shows which will consume the next
4 or 5 years. (32)

———

I don't visualize the final product. I don't know what will happen. I never do. (32)

———

I always work upside down, or at least the spray can is. (32)

———

Instinct and impulse are what actually make it happen. (32)

———

I think that my style of work—the paintings,
the characters—just lent themselves to sounds.

(3)

———

This conscious effort to enhance your own
recipes makes for better soup. (32)

———

Because most people don't read books.
Most people are fascinated by visual
imagery, music. (19)

———

The new get their education from the old
and they become the influence of tomorrow.
the cycle is completed when student will
become teacher. A position of education
of responsibility. (32)

———

Since I've started painting again, I feel
rejuvenated. There's a lot I didn't do my first
time around, and now I'm getting another
chance at it. Hell, some people never get a
chance at all. I feel very lucky. (32)

———

**[Describe how you feel when you
go out and paint.]**

Fearless, nervous, anxious and creative. (32)

———

**[Do any artists influence your work?
(Not just graffiti artists)]**

As a rule, NO, the trick is to NOT let these
directions show themselves … writers call it
BITING but nobody's fooling anybody. I run
my own style, abstract or otherwise. (32)

———

Remember: drink your milk before you use aerosol paint, this will coat your stomach and guard against nausea. (32)

———

Timeless is the keyword. Making work, "ahead of its time." (32)

———

Maybe we should call it art in public spaces, because there is such a range. Everyone wants to talk about the diversity of it. The pros and the cons. The good and the bad. It is so obvious, though: you see stuff on the wall and you know what is good and what is not. (5)

———

And if you had a dot com it just seemed like
you were commercial and you're asking for
loot. And I was not. I was looking for a
new wall to write on. (19)

———

People say, "Let's play within the rules."
I say, "No—let's break the rules a little bit." (7)

———

Youth and Youth Culture

As a kid, people always tell you what to do and keep you in a safe zone. But remember that nothing is set in stone. It's about choices and for young people, self-confidence. (1)

———

Young people don't have the patience and the vision to lean back and perhaps wait for something that they can't calculate will happen. (7)

———

Don't be intimidated. I think young people are looking for acceptance or they're looking for some kind of attention or recognition. But a lot of times that isn't there. (11)

———

I would call that individuals of street culture, lifestyle, atmosphere who embrace a youthful consumer society on a global level, whether it's Tokyo, London, Paris, Rome, New York. There's a new movement out there where kids are into toys, sneakers, accessories. (16)

———

I think young people are looking for acceptance or looking for some kind of recognition … But a lot of times that is not there, the acknowledgment, the support, the props, whatever you want to call it. (26)

———

The contraband is nearby … I don't have it with me at the moment. (32)

———

I think my small contributions have been
noticed and for that I am extremely grateful.
the next generation of writers and aerosol
expressionists need to have the spotlight to
themselves. this is their time. no longer mine.

(32)

Growing up in New York City you
start to go through the school system and
hear of this high school called Music and Art
[LaGuardia High School of Music and Art],
and that's where you go if you want to be
an artist. I couldn't get into M&A, they said
my portfolio was weak. So, I was initially
rejected from that and got really down
on art and got totally into music. (11)

The twelve-inch action figure range with all its accessories is dominating the current space available, with G.I. JOE and the STAR WARS universe battling for position. Other notables include PUPPET MASTER, SPAWN, MARS ATTACK, EVANGELION, DARK KNIGHT, FANTASTIC FOUR, THE ULTIMATE SOLDIER, FINAL FANTASY VII and TRON. But there's always more. (32)

To be quite honest, I didn't really think
I'd make it. (13)

———

You have to start with Supreme. And then it's
like, "Yeah … I respect in a way what they've
done … Because it's like, 'Man, you just went
in the whole system and like, kind of, did a
renegade take over.'" (20)

———

I love Virgil [Abloh]. The whole Off-White thing is really a special thing. I've been in places in Asia where the whole thing is so extreme from these kids' point of view. Like, how they want to rock stuff and be seen with items. But I don't know. From the sneaker to whatever your footwear, to your cap, it just seems like it's a full-on assault right now. (20)

———

All the cool kids in the neighborhood were wearing Cons [Converses]. (29)

———

I've been a child of the planet since
I was a kid. (17)

———

At that time, let's say 1969, I was 14 and I
was trying to look cool. Really Cons, Converse,
Chuck Taylor All-Stars, that was like the height
of urban street wear for that era. (29)

———

There is this romanticism about New York in
the '70s, as you could do what you wanted to,
but it was tough. The new New York is a police
state, but these are the times we live in; I still
love it there, it's still a village to me. (25)

At the age of (12) shortly after the assassination of MARTIN LUTHER KING JR. my mother and I marched along with thousands of others, down BROADWAY from HARLEM, in a nonviolent protest against racial inequality and the MURDER of DR. KING. At one moment, the situation escalated and suddenly MOLOTOV COCKTAILS were flying over our heads, the protest was met with extreme resistance from the NYPD and NATIONAL GUARD and we quickly found ourselves caught in between both factions. As TEAR GAS was deployed, my mother wrapped my face in a scarf and she evacuated me to safety. I will never forget the sounds of the barking dogs and watching individuals beaten with NIGHTSTICKS as they lay on the street. We took shelter with others inside of a

supermarket, and in closing, I will forever remember my mother applying first aid to those who were wounded and calmly telling me "baby get me some bags of ice." (24)

———

Here comes the '90s: clothing companies, a new direction for us to find our expression and ourselves. (19)

———

We're meeting the Japanese, finally now. You know, our introduction to them [the Japanese] happens '96/'97. There was essentially a Mo' Wax tour when I first met Nigo. (20)

———

It's like back how people used to buy records, and then toy collectors used to buy toys. It's the same thing for sneakers I think, and people do the same thing as well. (29)

———

And I guess you know the fashion of [graffiti] was taking hold. There was a kind of novelty of the whole culture being exposed to this white audience. (20)

———

Who will accept the challenge to take this youth into the future? can this change and social phenomenon occur on its own terms? will writers ever understand their legacy to the community? Is "the message" only personal? Aren't we communicating with the peoples around us? Eventually you must contribute to the society that has created you. And what are the consequences of the things that cannot be controlled? (32)

———

It has come to my attention that all things are not what they appear to be. The time for decisive action has arrived, and as the self-appointed keeper of this domain, I hereby disclaim any responsibility for any damages caused to those persons, places or things that will come under fire. (32)

More recently, I found that Converse tend to be disposable, in a way. You just rock them, and then they get paint on them and you're like, "All right, whatever." Get a new pair.

I think the price point has always been reasonable. For example, if I went into a shop and I saw the ones you're wearing now with the gold caps, I'd probably buy 3 of them.

Just to have them on standby. (29)

———

Art World, Market,
and Money

Forty years ago, like 1980—I sold a painting for $200. A small square painting. I remember going home later that night thinking, wow, that thing took me a couple of hours. That's a hundred bucks an hour. That's really good money. I thought, "Wow, maybe you can be successful as an artist, right?" (4)

———

All artists need patrons, buyers, and people who support them and keep them working. (1)

———

I never chased money. It looks like some is
arriving right now—thank you—it's better
late than never. I mean, I just turned 64. It's
about time the check came in. But at the same
time, I can still be gracious and feel like it's
not all for profit. It can't be. (14)

———

I remember I used to go into museums
and be like, Oh my God, so impressed with
the structure. It seemed so exclusive. So high
end. In reality, art is for the public, you know?
And one shouldn't be intimidated by
those structures. (4)

———

The bad stuff is your best ally. When we see really new interesting creative things, we recognize it easily because there is a void of it. We don't see enough of it. I encourage young artists to do what they want to do, but shortcuts are no guarantee. (5)

———

The introduction to the influential and artistic downtown scene is met with skepticism and eyes in the back of my head. The crowd is lively and extremely social, suddenly we have gone from total anonymity to some recognizable position. (32)

———

I mean, no one [can] exactly calculate the effect that public art has on public consciousness. (6)

———

It costs money to be independent. (19)

———

1979, '80, '81, '82, those were the wonder years in New York when it all started to incubate. People like Jean[-Michel Basquiat] and Keith [Haring] were more conscious of being artists, that was their thing. (28)

———

I don't know how or if all of these things
affect the street because all those names I
mentioned [Shepard Fairey, Os Gemeos, Blu],
they're in both worlds. They're on the street.
They're in the gallery. They're on a product.
They're on a Louis V bag. You're going to find
this melding of all of that now. (6)

———

It's not like I'm in my studio now trying
to bang out painting because there's money
to be made in selling paintings now.
I do other things. (6)

———

If it's not financially driven, then what's driving it? It's gotta be the right thing. I like to have relationships with the people I'm collaborating with. (6)

———

In '85, you had the death of street art as we knew it then. ... Everybody was done with it. Anything that could be sold found every buyer that would buy it. The market's over. It's done. (7)

Quite frankly, if I make a painting [for a commercial collaboration], there's nice numbers there. Why am I going to deny that? I think I've been in denial, because knowing that my dad busted his ass, and at the end of the year, that small fucking number that he sweated, cried, and bled for—that's a very small percentage of what I can make without lifting a finger. (7)

If people are ripping shit off, it's obviously better than no one interacting with it. (8)

For me, it's not about the money ... If I don't feel right about it, I'm not going to do it. (11)

———

Obviously, it's a realist tragedy. Every genre, every culture has fallen heroes. Keith [Haring], Jean-Michel [Basquiat], Andy [Warhol]. (13)

———

When I first started making painting in 1979–81, people were comparing me to [Wassily] Kandinsky and making references to other artists throughout art history whom I had never heard of. (13)

———

All the fashion and the hype, the "Oh these kids have all this energy" had passed by. It was a huge wave that carried a lot of people along with it. Fab Five Freddy [Fred Brathwaite], Keith [Haring], Kenny [Scharf] and a lot of the young artists of that generation, we were really close and we shared a lot of information but it wasn't until the early '90s that I started to consider myself as "an artist." (13)

———

The transition from the street and the subway to the gallery is a very difficult one; how do you justify the content of your work now that it's in a gallery? Doesn't it limit its power being off the public spaces? (13)

———

I look at a gallery space and I want to put work on the wall that's going to consume the wall, as opposed to the way I used to think, which was the space is going to consume my work. (13)

———

There are many pioneers who have (through the very fact that they were there) established the standard by which excellence will be determined. (30)

———

It wasn't all smooth sailing: in 1986–87, the art world was all over for all of us. There was no more status, or representation, or exhibitions, or interest, or clients, or money—nothing. (18)

———

One day, people are gonna be referencing other people's work to my work. (19)

———

When I examine a particular piece of work, painting/graphic/whatever, I ask myself, how would this be viewed, years from now, along other contemporary work? (32)

———

Why is Jean-Michel [Basquiat] so successful?

Well, he's been dead a quarter century, no doubt. But when he was active, he knew about [Cy] Twombly, he knew about [A. R.] Penck. He knew that he was making these strokes that people were like, "Yo, my kid could do that shit." And I was like, "Yeah, maybe. But does she know what she's doing?" And everyone thought Jean was like, "Oh, yeah ... Blah, blah, blah" but no, he was mad smart. And he was paying homage and kind of throwing it back in their faces. And they loved it, right? And they loved it. (19)

I see artists that are so prolific and they're
just banging it out and banging it out and
banging it out. (19)

———

You know, if I put my mind to it, I can
produce some good paintings.
That's no doubt. (19)

———

I understand now, that being THAT type of
an artist, one who works within the gallery
structure, to attempt to exhibit and sell work
is NOT something that I really WANT to do.

(32)

The dilemma seems to be that in the
ARTWORLD once you've established yourself
and a particular style of work, you're locked
in to creating the same/similar work that
people are familiar with. (32)

There's so much revisionist history, people can say what they want ... but Jean[-Michel Basquiat] was a very good friend and he was part of all of it. I remember thinking, "Wow, he's doing a very permanent thing." And people said, "Oh, my kids could do that." But no one understood he was interpreting Cy Twombly, and he was showing relationships in art, which is what the art world wants you to do. What he created gave it respect. It's cyclical. He was a master. (28)

We meet the guys from Harajuku ... Because the Japanese were always bringing artists out so it would be possible to meet artists from the UK and all that kind of stuff, you know, out there. So, it was very interesting in the sense that they always seemingly had the budget, the desire, the resources. You know they could always make stuff happen and meeting artists in Japan seemed frequent. (20)

———

The fact that [Jean-Michel] Basquiat isn't here is a real tragedy. Everything that he's done and everything that's said of him is all worthy. He was way ahead of his time. He was a brilliant artist. (28)

———

I like public art more than galleries. (28)

———

You seem to be doing well, selling work,
the collectors are happy, the gallery is certainly
happy. But then again, they should be;
they take in a hefty 50% despite whether
or not they actually aided in any way to
establish your/the market price, and
YOU BELIEVE THE HYPE. (32)

———

Like being asked to complete a homework
assignment, painting became something
that had to get done. (32)

———

Hard to hear the customer's galleries ask you
to re-do the same painting but in blue so it
matches their sofa. (34)

———

Art critics killed me saying that I was copying
[Wassily] Kandinsky. I actually did not even
know him. (34)

———

Europeans were very important because they were supporting what we were doing and looking at it like, "Oh, guys, you guys are amazing." When the American perspective was like, "Fuck, man, you guys are horrible." (19)

I have always disliked the restrictions of the ARTWORLD. (32)

Advice and Hindsight

Write, design, promote, launch, publish, engage, incorporate. You're already doing it, you just need to reconfigure the hard drive. (32)

However; if you're not willing to look, you'll never see. (32)

The Past gets lost in moles of memories … the origins are forgotten and possibly in some cases: unknown. (21)

History is distorted and the future soon becomes yesterday ... the anticipation of tomorrow and perpetual change. (21)

———

Remember: TAKE WHAT YOU WANT, BUT NEED WHAT YOU TAKE. (32)

———

Let me say this. As a human, not an artist,
I feel it's very important to contribute to
this planet in some way. The challenge of
interaction with the world at large faces us all.
I have chosen many paths to express myself
and don't feel limited by any one medium in
particular. It's relative to what's going on
around you, and the influences you have
or create. (32)

———

I'm older now and don't have the desire to hang on the scene so to speak. I think things have changed as far as "hip-hop" goes, and it's obvious that the (G) experience will never be the same as "back in the day." (32)

———

The phoniness of certain individuals is always a concern. The posers. The players. The wannabees. The has-beens. The cheeba hawks. The gravitators. The make-believers. The liars. The cads. (32)

ALWAYS resist being one dimensional and look for other means of creative outlet. (32)

The option is clear, enjoy with unconditional happiness and make these petite moments ones of pleasure and surprise. (32)

Hopefully, I inspire, I educate, I have something positive to say. (7)

The inspiration … lies in the moment. (1)

———

I even have had that [retirement] chat
with myself. How am I going to do it?
Because honestly, yeah, I'm the Beatles when
I'm 64. Okay. Who cares? But I need another
30, okay. I need another 30 for sure.
So maybe at 94. (4)

———

What's next for me? Is it existential? Yes, it is actually. Because, there are things happening in this process that are very rewarding. I don't mean making money, because that is not rewarding for me. I think anyone with any intelligence can find a way to do that. I am more interested in relationships and the emotions of the people I am around. (5)

———

I've traveled around a lot, and I don't take things for granted. I'm always like, "Wow, this is amazing," and, "Oh man, I'm so lucky to be here." (29)

———

Whatever your potential and current situation,
know that life is very transient and temporary.
We're all capable of changing everything.
Work on it, fix it and change it.
But don't be discouraged. (1)

———

Entering the world of the unknown,
is always a scary proposition. It takes desire
and curiosity. It takes an open mind.
It is our ... destiny. (32)

———

I would just say to a young person, "Don't listen to anyone, you have to pursue what you're hearing inside your own head." (11)

―――――

I also suggest wearing a mask regardless of how confining they can be. Just because I've lost some years doesn't mean you have to. In the end, use common sense concerning ventilation and food consumption. (32)

―――――

What's next? Good question. Really. And I will certainly avoid it. (9)

The thing that really upsets me is the conflict in the world—I'm old enough to remember the Vietnam War—what have we learnt? (25)

I never invited you here, so don't expect me to be courteous. I will not hear your critiques or your criticisms. (32)

I'm not someone who can sit back: I have
to look to the future and the exciting things
that will happen there. (18)

———

Impressionistically, there's the World's Fair
in New York, in 1964—our school took us
out there and talked to us about how the
world was going to be. It was a very
optimistic vision, kind of a dream period
with jetpacks and all this other stuff that
never really happened. (18)

———

I was way short-sighted in my vision of
what the future was. (19)

———

Personally, I'd like to live for another quarter
of a century at least. So … at 63 … 88? No,
fuck it. People are living till 100. I wanna die
at 100. So, I'm still going with no sort of
pause in my game, you know. (19)

———

I want to get off the planet. For a moment.
Maybe it's my last trip, that'd be dope. Just to
say that the future's unlimited, guys. (19)

———

At my age, some fifty years after my first experiences at civil rights rallies and demonstrations against the inequalities of racial injustice. The anti-war protests and the rainbow movements. The disparities between women and men and equal pay for all. The right to choose, the right to life, the right to live, and not be treated like something inferior or not equal, is simply no longer FUCKING acceptable. I am very disappointed with the image of my country. (22)

———

We're living in a very fake world. It worries me. I'm very old school. There should be more interaction between us. (28)

———

Keep doing your thing and as much as possible try to get out into dangerous territory just to check on your skills. I mean, nothing extreme, of course. Just push the limits. (1)

———

The conservatives … want to hold on to shit and keep it as it was, stopping progress in whatever form it takes. (7)

———

We're actually too ahead of our time. (19)

———

SOURCES

1. Shazzani, Amirul. "'I hope to keep going for another quarter of a century': An Interview with Legendary Street Artist Futura." Straatosphere, June 13, 2019. https://straatosphere.com/futura-interview-street-artist-singapore-2019/.

2. Barnard, Adam Mark. "When Two Worlds Collide: ACRONYM x FUTURA." *Hypebeast Magazine*, December 3, 2015. https://hypebeast.com/2015/12/futura-errolson-hugh-interview.

3. Spence, Simon. "Futura 2000 Is Now." *Japan Times*, May 30, 2001. https://www.japantimes.co.jp/culture/2001/05/30/arts/futura-2000-is-now.

4. Esteller, Keith. "In Conversation with Futura." *Hypebeast Magazine*, Issue 27: The Kinship Issue, December 10, 2019. https://hypebeast.com/2019/12/futura-interview-hb-magazine-issue-27-kinship-artist.

5. Dominique. "Knotoryus Talks to the Legendary Futura." *Knotoryus*, October 23, 2013.

6. Wilson, Gaby. "Futura Talks Rise of Street Art and Collaboration Strategy in Exclusive Interview." *MTV Style*, October 26, 2012.

7. Harris, R. Anthony. "RVA #10: The Interview with a Street Art Original, Futura." *RVA Mag*, October 8, 2012. https://rvamag.com/art/richmond-mural-project/rva-no-10-futura.html.

8. "SF Interview with Futura." *Sneaker Freaker*, March 23, 2013.

9. "Interview with Futura!!" *The Brilliance!* http://www.thebrilliance.com/interviews/futura.

10. Cenat, Diana. "Interview with Diana Cenat." *Wild Magazine*.

11. Hafer, Austin. "Futura Bold." *Twelv Magazine*, August 10, 2013. https://twelvmag.com/people/futura-bold?page=1.

12. "Futura 2000 Interview." *GLLTN*, November 16, 2009. https://glltn.com/futura-2000-interview-english-version/.

13. Ledgerwood, Angela. "Futura Reflects on the Past." *Interview Mag*, August 8, 2012. https://www.interviewmagazine.com/art/futura-exhibit.

14. Sanchez, Karizza. "Futura Talks Relaunching Futura Laboratories, Levi's Collaboration, and Off-White Nike Dunk Low." *Complex*, December 17, 2019. https://www.complex.com/style/2019/12/futura-talks-off-white-nike-dunk-collaboration-futura-laboratories-relaunch.

15. "Futura 2000 Photography Interview." *Graffuturism*, April 3, 2010. https://graffuturism.wordpress.com/2010/04/03 /futura-2000-photography-interview/.

16. Maloney, Tim. "The (Lenny) Futura Is Now." *Cycling News*, July 18, 2005. https://www.cyclingnews.com/features /the-lenny-futura-is-now/.

17. "Futura 2000 in Studio and 'The 5 Elements.'" *Brooklyn Street Art*, January 10, 2019. https://www .brooklynstreetart.com/2019/01/10/futura-in-studio -and-the-5-elements/.

18. "A Conversation with Futura." Hennessy. This interview is no longer available on the website.

19. Mare, Carlos. "Futura—From Graffiti to Galleries at Sole DXB." *Sole DXB*, 2018. https://www.youtube.com /watch?v=TosRvGQg-Qo.

20. Morgan Gesner, Eli. "How Futura 2000 Went from Graffiti Pioneer to Streetwear Icon." *Uproxx*, September 25, 2019. https://uproxx.com/style/futura-graffiti-style/.

21. Futura. Wall text for *NEW HORIZONS*. *NEW HORIZONS*, June 18–September 3, Library Street Collective, Detroit. Pictured on *Artsy*. https://www.artsy.net/show/library -street-collective-futura-new-horizons.

22. Instagram post. @futuralaboratories. June 15, 2020.

23. Leonard McGurr in conversation with Shi Lei Wang, Brooklyn, New York, June 4, 2020.

24. Leonard McGurr in conversation with Shi Lei Wang, Brooklyn, New York, June 2, 2020.

25. Darby, A JW. "José Parlá & Futura." *Being Hunted*, 2007. http://www.beinghunted.com/v51/news/2007/09/jose_parla_futura_pirate_utopias/jose_parla_futura_pirate_utopias.html.

26. Eisinger, Dale. "Interview: Futura Talks about His Collaboration with German Illustrator Ramona Ring about an Album Cover Project for the Charity (RED)." *Complex*, October 9, 2013. https://www.complex.com/style/2013/10/futura-interview-october-2013.

27. Cheong, Wayne. "A Retrospective and an Interview with the Godfather of Graffiti, Futura." *Esquire Singapore*, August 28, 2019.

28. Fortuny, Margo. "The Aerosol Optimist: An Interview with Futura 2000." *Exit Mag*, 2012. http://margofortuny.blogspot.com/2015/03/aerosol-optimist-interview-with-futura.html.

29. Wu, Yu-Ming. "Futura Speaks on the Converse Made by You Campaign." *Freshness Mag*, March 24, 2015. https://www.freshnessmag.com/2015/03/24/futura-speaks-on-the-converse-made-by-you-campaign/.

30. "Futura Speaks." *Graffiti.org*, 1996. https://www.graffiti.org/futura/futura.html.

31. Burns, Chris. "SlashGear Interviews Futura 2000 on Samsung and the Power of Cross-Branding." *SlashGear*, October 26, 2012. https://www.slashgear.com /slashgear-interviews-futura-on-samsung-and-the -power-of-cross-branding-26254202/.

32. Internet Archive, 1998–2009 writings by Futura. https://web.archive.org/web/20080315183308 /http://home.dti.net/futura/playboy.htm.

33. Futura 2000. *Dedicated to STAYHIGH149*. Back cover.

34. Email from Patrick Lerouge to Peter Brockman, May 6, 2020.

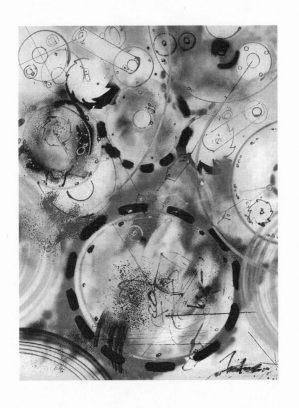

CHRONOLOGY

1955
Arrival: Beamed down to the planet: New York City

1955–69
Experience: Limited

1955–70
Annual summer travel with Mother to Chicago, Illinois

1960
First amusement park: FRONTIERLAND

1964–65
Inspiration: World's Fair—Queens, New York
Palisades Park

1965–68
Boy Scouts: Rank: Life Scout

1967
Inspiration: visual: graphic design, coca cola, IBM

1968
Influence: 2001: *A Space Odyssey, Planet of the Apes*

1969
Space Race: Man on the Moon

1970
DAWN of a DECADE
Invention: graffiti artist

1971
Nom de plume: FUTURA2000
Establishment with Marc "Ali" Edmunds: Soul Artist
 (a.k.a. S.A. Inc.)

1972
Education: Louis D. Brandeis High School

To celebrate his graduation, Futura's father took him to
Peter Luger's Steakhouse for the first time. It has since
become one of his favorite restaurants for all occa-
sions. Pretty much everyone at Luger's knows him.

1973
Higher education: CCNY [City College of New York]
dropout
The One Tunnel pyrotechnic incident

1974–78
Career opportunities: US Military Service
Rank: Petty Officer 3rd Class: McGurr
First ship: *Hancock*
Second ship: *Constellation*
First intro: Asia

1975
First tattoo: Pink's Tattoo Parlor, Hong Kong
INLOVINGMEMORY: Mother

1977

Star Wars movie released. Watched in Manila, Philippines, while he was stationed in the navy. Subtitles were in Tagalog.

1978

Return to New York City
1978–79
Resident of Savannah, Georgia
Employment: WSGA Radio Station: Janitor and On-Air Personality

1979

Return to New York City
Insertion: Street art community
Met Keith Haring, Fab 5 Freddy, Eric Haze, and Zephyr (on separate occasions)
Zephyr introduced many graffiti writers to Futura
Fab 5 Freddy introduced the other cool people

1980

DAWN of a DECADE

Exposure: Subways & galleries

Met Dondi White, Martha Cooper, Henry Chalfant, Kenny Scharf

Esses Studio at Upper East Side (Seventy-Seventh Street and York Avenue) for two months. It was the central location for various graffiti writers. This is where Futura stretched and painted his first canvas. Futura and Zephyr stretched all of the canvas at the studio.

Met Lee Quiñones at Esses Studio

Met Jean-Michel Basquiat at Soul Artist studio, where Keith Haring used to hang out (one day, he brought his friend)

Abstraction: The "BREAK" train (2/3 Line on Utica Avenue), Dondi being a lookout while Futura and Zephyr painted their own trains.

Graffiti Art Success for America (GAS) group exhibition at Fashion Moda in the Bronx, New York

1981

Influence: Recognition

Tour: The Clash (live painting onstage)

April: *Beyond the Words* group exhibition at Mudd Club, New York, New York

New York New Wave group exhibition at P.S.1, Long Island City, New York

Artists Invite Artists, New Museum, New York, New York

1982

External: Cultural exploration/exploitation

New York City Rap Tour, France & UK

French Connection

FNAC show, Strasbourg, France

Solo exhibition at Fun Gallery, New York, New York

Kenny Scharf & Futura 2000 at Tony Shafrazi Gallery, New York, New York

51Xpressionism, group show at Gallery 51X, New York, New York

New York Now, Exposition Itinerante, Kestner-gesellschaft, Hanover, Germany

Group show with Dondi and Zephyr by Jeffrey Deitch
at Bank of America, Hong Kong

Group Show, P.S.1, New York, New York

Group Show with Dondi and Zephyr, UCSC Santa Cruz,
California

Group Show at Fashion Moda, Bronx, New York

1983

Conclusion: Chemical imbalance

Music: The Escapades of Futura

January: *Champions* group exhibition at Tony Shafrazi
Gallery, New York, New York

Painting Sculpture Totems & 3D, Tony Shafrazi Gallery,
New York, New York

Solo exhibition at Fun Gallery, New York, New York

Solo exhibition at Yvon Lambert Gallery, Paris, France

Solo exhibition at Yaki Kornblit Gallery, Amsterdam,
Netherlands

Group exhibition at American Graffiti Gallery, Amster-
dam, Netherlands

Futura 2000 solo exhibition at Baronian-Lambert Gallery,
Gent, Belgium

Solo exhibition at Four Blue Squares Gallery, San
 Francisco, California
Graffiti group exhibition at Boijmans Museum,
 Rotterdam, Netherlands
Group exhibition at Lucky Strike (RIP), New York,
 New York
Group exhibition at Monique Knowlton Gallery,
 New York, New York
Solo show at 51X Gallery, New York, New York
Group exhibition at Gallery 121, Antwerp, Belgium
Group exhibition at Zellermayer Gallery, Berlin, Germany
Group exhibition at Fay Gold Gallery, Atlanta, Georgia
New Art at the Tate Gallery, Tate Gallery, London, UK
Group exhibition at Greenville Museum, South Carolina
Post-Graffiti group exhibition at Sidney Janis, New York,
 New York
Wild Style movie released by Charlie Ahearn. Charlie and
 Fab 5 Freddy were offered a role in the movie but
 turned it down because of prior commitments with
 The Clash. But Futura was able to make a cameo
 along with Dondi.

1984

USSR: Moscow trip

Fatherhood: Timothy Louis McGurr, New York, New York

Solo exhibition at Fun Gallery, New York, New York

Solo exhibition at Yaki Kornblit Gallery, Amsterdam, Netherlands

June: Solo exhibition at Shafrazi Gallery, New York, New York

Homage to Picasso group exhibition at Shafrazi Gallery, New York, New York

New York Graffiti group exhibition at Groninger Museum, Groningen, Netherlands

Rapid Enamel: The Art of Graffiti group exhibition at the Renaissance Society at the University of Chicago, Chicago, Illinois

New York Graffiti group exhibition at Seibu Gallery, Tokyo, Japan

New York Graffiti group exhibition at Gallozzi-LaPlaca Gallery, New York, New York

New York Graffiti group exhibition at Robert Fraser Gallery, London, UK

New York Graffiti group exhibition at Louisiana, Copenhagen, Denmark

Arte di Frontiera group show, Bologna, Italy *Classical American Graffiti Writers and High Graffiti Artists* group exhibition at Galerie Thomas, Munich, Germany

Met Patrick Lerouge, his number one collector, during a Herbie Hancock concert with Grand Mixer D.S.T.

1985

INLOVINGMEMORY: Mother

Solo exhibition at Shafrazi Gallery, New York, New York

Solo exhibition at Michael Kohn Gallery, Los Angeles, California

Group exhibition at Flow Ace Gallery, Los Angeles, California

Group exhibition at Kentucky Litho Building, Louisville, Kentucky

Met Stash

Aftermath: Death of a movement

1985–2000

Annual summer travel with family to Lorgues, France

1986–89
Professional employment: Bike messenger

1986
February: Solo exhibition at Semaphore Gallery,
New York, New York

1987
Group Show, Michael Kohn Gallery, Los Angeles,
California
INLOVINGMEMORY: Andy Warhol

1988
Professional employment: Postal service
Solo exhibition at Philippe Briet Gallery, New York,
New York
Patron: Agnès B., introduced by Philippe Briet. Set up
Hope Street studio for two years, which got Futura
painting again
Group exhibition at Museum of American Graffiti,
New York, New York
INLOVINGMEMORY: Jean-Michel Basquiat

1989

Solo exhibition at Philippe Briet Gallery, New York,
New York

Solo exhibition at Galerie du Jour by Agnès B., Paris,
France

Solo exhibition at Musée de Vire by Philippe Briet,
Normandy, France

Solo exhibition at Galería d'Art Contemporani by Arcs
& Cracs, Barcelona, Spain

Street mural, Barcelona, Spain

Group exhibition at Michael Kohn Gallery, Los Angeles,
California

Group exhibition at Gallery Du Jour, Paris, France

1990

DAWN of a DECADE

Fatherhood: Tabatha Isadora McGurr, Draguignan, France

Solo exhibition at Gallery B5, Fontvieille, Monaco

Solo exhibition at Philippe Briet Gallery, New York,
New York

INLOVINGMEMORY: Keith Haring

1991

STREETWEAR: Independent clothing companies: GFS

Met James Jebbia, possibly at his first store Union,
New York, New York

Solo exhibition at Galerie du Jour by Agnès B., Paris,
France

Group exhibition at Federal Reserve, Washington, DC

Group exhibition at Trocadéro Museum, Paris, France

Solo exhibition at Structures, Montpellier, France

Group exhibition at Liverpool Gallery, Brussels

Group exhibition at Colleen Greco Gallery, Nyack,
New York

Group exhibition at Martin Lawrence Gallery, New York

Group exhibition at Brooke Alexander, New York

1992

Professional employment: Kinko's

Solo exhibition at Galerie du Jour by Agnès B., Paris,
France

May: The Clash "Overpowered by Funk" featuring Futura
2000

October: *Graffiti* group exhibition at Klarfeld Perry
Gallery, New York, New York

Coming from the Subway group exhibition, Groninger
 Museum, Netherlands
Group exhibition at Empire Gallery, New York, New York
Group exhibition at Thread Waxing, New York, New York
Group exhibition at David Leonardis Gallery, Chicago,
 Illinois

1993
Intro: Tokyo
Soundtrack: MOWAX
Solo exhibition at 01 Gallery, Los Angeles, California
Group exhibition at Picasso Museum, Antibes, France
Solo exhibition at Martin Lawrence Gallery, New York,
 New York
Group exhibition, Time Space Light, New York, New York
Group exhibition, Berlin Art Academy, Berlin, Germany
Participant at Cycle Messenger World Championship,
 Berlin, Germany

1994
Design group: BFS/PROJECT DRAGON

Solo exhibition at Time Space Light, New York, New York

Spray Can Art group exhibition at Sixth Congress Gallery, Tucson, Arizona

Group exhibition at Gallery De Beaux-Arts, Lorient, France

Solo exhibition at Gallery Cotthem-Knokke, Barcelona, Spain

INLOVINGMEMORY: Marc "Ali" Edmonds

1995

Group exhibition at C World, New York, New York

Group exhibition at Alcorcón, Madrid, Spain

Group exhibition at Agnès B., Paris, France

Group exhibition at TBM EXPERIMENT, Rome, Italy

Group exhibition at Camden Town, London, UK

1996

Transition: Welcome to my website

Sk8thing introduced Futura to Nigo at his store Nowhere, Tokyo, Japan

Met Hiroshi Fujiwara, Jun Takahashi

January: Solo exhibition at Livestock Gallery, New York,
New York
Group exhibition at L'Aéronef, Lille, France
Solo exhibition at Solaria, Fukuoka, Japan
Group exhibition at Summersault, Melbourne, Australia

1998
Extension: FUTURALABORATORIES / UMBRELLA /
TARANTULA
INLOVINGMEMORY: Dondi White

1999
UNDERCOVER COLLABO
Production: Three-dimensional characters
Variant home exhibition by Futura 2000, Greenpoint,
New York
Group exhibition at SSUR Gallery, New York, New York

2000
DAWN of a CENTURY
Futura book by Booth-Clibborn, publisher

DeFuMo with Delta and Mode2 at More Club, Modena,
 Italy
November: *Command Z* with Stash at BAPE store, Tokyo,
 Japan

2001
Commercial: Levis x Futura, Tokyo, Japan
Futura 2000 solo exhibition at Colette, Paris, France
9/11: When the world changed forever, New York,
 New York

2001–7
Shared office with Stash

2002
Experience: Advanced aerosol abilities
Session the Bowl group exhibition by Deitch Projects,
 New York, New York
Met Mark Parker in his office, Brooklyn, New York
INLOVINGMEMORY: Joe Strummer

2003
Placement: Nike / Medicom / North Face

2004
Retail store: FUTURALABORATORIES, Fukuoka, Japan
"FOR LOVE or MONEY" (FLOM) NIKE SB sneaker
 release, courtesy of Mark Parker
Tour de France invite from Mark Parker

2005
November: HAPPY 50th FUTURA, Honolulu, Hawaii
Years in Pictures solo exhibition at V1 Gallery, Copenhagen,
 Denmark
Tour de France: Livestrong x Nike project

2006
Event Horizon: Silly Thing Occupation: battery charger
Sneaker Pimps, New York, New York
Bangkok Dangerous: Coup d'état

2007

Chinese Connection

July: *Pirate Utopia* group exhibition with José Parlá at
 Elms Lesters, London, UK

2007–8

Personal world tour: Chile, Bolivia, Argentina, Venezu-
 ela, Paraguay, Brazil, Peru, Panama, Guatemala, Cuba,
 Finland, Estonia, Bulgaria, Czech Republic, Greece,
 Hungary, Iceland, Latvia, Lithuania, Romania, Egypt,
 Morocco, Kenya, Tanzania, Tunisia, Cambodia

2008

September: *Strategic Synchronicity* by Krunk, Los Angeles,
 California

After twenty years at Hope Street studio, Futura moved
 out. A few of his paintings and a personalized Dondi
 White piece were stolen during the move.

2008–9

Tour of MLB: Cathedrals of the Game

2009

December: Wynwood Walls by Goldman Global Arts, Miami, Florida

December: *Stages* group exhibition at Art Basel, Miami, Florida

2010

DAWN of a DECADE

August: Painting with Os Gemeos at P.S.11, New York, New York

Participant at Cycle Messenger World Championship, Panajachel, Guatemala

INLOVINGMEMORY: Rammellzee

2011

Fukushima nuclear plant disaster; FUTURALABORATO-RIES store closed, Fukuoka, Japan

April: *Art in the Streets* group exhibition at MOCA by Jeffrey Deitch, Los Angeles, California

May: Carbon Festival, Melbourne, Australia

June: *Kindergarten* group exhibition at Galleria Civica Di Modena, Modena, Italy

September: *3 Kings* group exhibition with Lee Quiñones and Fab 5 Freddy at Subliminal Projects Gallery by Patti Astor, Los Angeles, California

2012

February: *Expansions* solo exhibition at Galerie Jérôme de Noirmont, Paris, France

July: Hennessy VS Cognac Bottle Launch, North America Tour

September: *Futura-Shock* solo exhibition by Andy Valmorbida, New York, New York

November: *Deep Space* group exhibition with Phase 2, Rammellzee, and Matta, New York, New York

All City Canvas festival painting, Mexico City, Mexico

2013

Hennessy VS Cognac Bottle Launch, World Tour

2014

June: *Introspective* solo exhibition at Magda Danysz Gallery, Paris, France

June: Painting at Piscine Molitor, Paris, France

June: Underground painting with Mode2, Lek, and Sowat at Palais de Tokyo, Paris, France

August: *The Language of the Wall* group exhibition at Pera Museum, Istanbul, Turkey

September: *City as Canvas: Graffiti Art from the Martin Wong Collection* at the Museum of the City of New York by Sean Corcoran, New York, New York

October: Painting at basketball court for Sprite with LeBron James, Akron, Ohio

October: *Time Warp* solo exhibition at State Museum of Architecture by Belief, Moscow, Russia

November: *Kinetic Action* solo exhibition at Magda Danysz Gallery by Converse, Shanghai, China

November: *Rehlhatna* [Our Journey], world record for longest graffiti scroll, various artists, Dubai, United Arab Emirates

2015

May: *The Bridge of Graffiti* group exhibition at Venice Biennale, Venice, Italy

September: The Bowery Wall by Goldman Global Arts,
 New York, New York
August: Coney Art Walls by Jeffrey Deitch, Brooklyn,
 New York
September: Nuart Art Festival, Stavanger, Norway
November: HAPPY 60th FUTURA, Venice, Italy

2016
February: Solo exhibition at Known Gallery by Converse,
 Los Angeles, California
June: Rose Béton Festival, Toulouse, France
June: *New Horizons* solo exhibition by Library Street
 Collective, Detroit, Michigan

2017
November: Colette / Chanel / Futura, Paris, France

2018
March: *Sneaker Pimps*, Mumbai, India
May: *Beyond the Streets* group exhibition by Roger
 Gastman, Los Angeles, California

December: *Chez Nous* group exhibition with André
 Saraiva at Magda Danysz Gallery, Paris, France
Futura 2000: Full Frame book release by Drago Publisher
INLOVINGMEMORY: Sandy Bodecker

2019

January: *The 5 Elements* solo exhibition at Urban Spree,
 Berlin, Germany
January: Live painting at Louis Vuitton Men's AW20
 Runway, Paris, France
February: Painting at Supreme flagship store, New York,
 New York
March: *Abstract Compass* solo exhibition at Art Basel, Hong
 Kong
April: Jean-Michael Basquiat Talk at Guggenheim, Abu
 Dhabi, United Arab Emirates
May: *Constellation* solo exhibition by A Culture Story,
 Singapore
August: DeFuMo with Delta and Mode2 at La Karrière,
 Villars-Fontaine, France
July: *Beyond the Streets* group exhibition by Roger
 Gastman, Brooklyn, New York

July: Off-White Men's SS20 collaboration launch,
Paris, France

July: Group exhibition at Kaikai Kiki Gallery, Tokyo,
Japan

July: New York Mets Capsule / First pitch with son,
@13thWitness, Queens, New York

September: Group exhibition at Rabat Biennale, Rabat,
Morocco

October: *10 Years Wynwood Walls*, Goldman Global Arts,
Miami, Florida

November: *Generation Z* solo exhibition at the Mass
Gallery, Tokyo, Japan

INLOVINGMEMORY: Phase II

2020

DAWN of a DECADE

January: Comme des Garçons collaboration launch,
Paris, France

February: BMW M2 Art Car launch, Los Angeles,
California

April: Modernica furniture launch

Futura book by Rizzoli Publications
Futura-isms book by Princeton University Press
Conclusion: The futura is written.
04.28.2020
Thank you.

ACKNOWLEDGMENTS

First and foremost, my thanks go to Futura, to whom the words and thoughts on these pages belong. It is my honor to know and to work with such an inspiring, creative mind. My thanks as well to Shi Lei Wang, Timothy, and Tabatha for their endless support of Lenny and his vision.

My sincere thanks to Sky Gellatly for his extraordinary collaboration on this and other projects, and to Nikle Guzijan and Pete Brockman for their much-appreciated assistance. Our sincere thanks as well to Patrick Lerouge for his insightful comments and contributions.

My heartfelt appreciation to the entire team at Princeton University Press, especially Michelle Komie, Christie Henry, Terri O'Prey, Cathy Slovensky, and Kenneth Guay. We remain extremely grateful to PUP for their continued professionalism, encouragement, and passion for our projects together throughout the years.

I am immensely grateful to Carlo McCormick for his invaluable insights, guidance, and active participation throughout the formation of this book.

Very special thanks to Fiona Graham for her invaluable research and organization of this publication.

Additional thanks go to a celebrated group of friends, colleagues, and supporters of Futura, including (but not limited to): Stash (Josh Franklin), Crash (John Matos), Martha Cooper, Lee Quiñones, Jahan Loh, Rich Colicchio, Mary-Ann Monforton, Hannah Alderfer, Michael Holman, Jeffrey Deitch, Virgil Abloh, Nick Taylor, Tony Shafrazi, Kenny Scharf, Fab 5 Freddy (Fred Brathwaite), Maripol, Keith Miller, Patti Astor, Bill Stelling, Rene Ricard, Hiroko Onoda, Steven Lack, Franklin Sirmans, David Stark, Sarah Sperling, Daniel Arsham, John Cahill, John Pelosi, Angelo DiStefano, Carlos "oggizery_los" Desrosiers, Kevin Wong, Keith Estiler, Vanessa Lee, Karl Cyprien, Amanda Scoledes, Mike Dean, and Louise Donegan.

I humbly honor those in memorium: Kiely Jenkins, Allan Arnold, Bobby Breslau, David Spada, Arch Connelly, Rammellzee, Michael Stewart, David Wojnarowicz, Adolfo Sanchez, Dan Friedman, Henry Geldzahler, Tseng Kwong Chi, Danny Acosta, Richard Marshall, Christine Zounek, and O.W.

My sincere thanks to Taliesin Thomas for her amazing assistance on this and many other projects, and to Steven Rodríguez and Susan Delson for their continued support. Thanks as well to Aemilia Techentin for her supporting research.

Finally, I give all my bottomless gratitude to my amazing wife, Abbey, and to my wonderful children, Justin, Ethan, Ellie, and Jonah, for their love and encouragement.

As always, I give endless love and thanks to my mother, Judith.

<div align="right">LARRY WARSH</div>

FUTURA (Leonard McGurr) A pioneer when graffiti met the formal gallery ecosystem, artist Futura (a.k.a. Futura 2000) was known as early as the 1970s for his radical approach in the street, where he introduced abstraction to a predominately letter-based discipline. Born Leonard Hilton McGurr, his work on canvas caught attention in the 1980s, establishing him as a leading voice within a wider movement that included the likes of Jean-Michel Basquiat and Keith Haring. Self-taught in what he calls "the subway school," Futura is celebrated alongside his friends Dondi White and Rammellzee for his progressiveness and of-the-moment dynamism.

His work has been exhibited at notable museums such as MOCA in Los Angeles, MoMA P.S.1 in New York, the New Museum in New York, and, most recently, the Boston Museum of Fine Arts (MFA). Futura's current gallery partner is Kaikai Kiki Gallery, founded by Takashi Murakami.

Through his dedicated design studio and product brand, Futura Laboratories, McGurr has collaborated with partners such as Louis Vuitton, Comme des Garçons, Chanel, Nike, and Off-White; he has also designed music packaging for The Clash and DJ Krush, and performance visuals for Lupe Fiasco and Virgil Abloh.

Larry Warsh has been active in the art world for more than thirty years as a publisher and artist-collaborator. An early collector of Keith Haring and Jean-Michel Basquiat, Warsh was a lead organizer for the exhibition *Basquiat: The Unknown Notebooks*, which debuted at the Brooklyn Museum, New York, in 2015, and later traveled to several American museums. He has loaned artworks by Haring and Basquiat from his collection to numerous exhibitions worldwide, and he served as a curatorial consultant on *Keith Haring | Jean-Michel Basquiat: Crossing Lines* for the National Gallery of Victoria. The founder of *Museums Magazine*, Warsh has been involved in many publishing projects and is the editor of several other titles published by Princeton University Press, including *Basquiat-isms* (2019), *Haring-isms* (2020), *Futura-isms* (2021), *Abloh-isms* (2021), and *Arsham-isms* (2021), *Jean-Michel Basquiat: The Notebooks* (2017), and two books by Ai Weiwei, *Humanity* (2018) and *Weiwei-isms* (2012). Warsh has served on the board of the Getty Museum Photographs Council and was a founding member of the Basquiat Authentication Committee until its dissolution in 2012.

ILLUSTRATIONS

Frontispiece: Portrait of Futura. Photo © Ryan Plett

Page 126: Futura, *Untitled*, 1985, 162 × 124 cm,
 Collection Château de Forbin

ISMs

Larry Warsh, Series Editor

The ISMs series distills the voices of an exciting range of visual artists and designers into captivating, beautifully made books of quotations for a new generation of readers. In turn passionate, inspiring, humorous, witty, and challenging, these collections offer powerful statements on topics ranging from contemporary culture, politics, and race, to creativity, humanity, and the role of art in the world. Books in this series are edited by Larry Warsh and published by Princeton University Press in association with No More Rulers.

Futura-isms, Futura
Haring-isms, Keith Haring
Basquiat-isms, Jean-Michel Basquiat
Weiwei-isms, Ai Weiwei